1-27-06

Handmade
Silk Ribbon
Greetings Cards

Ann Cox

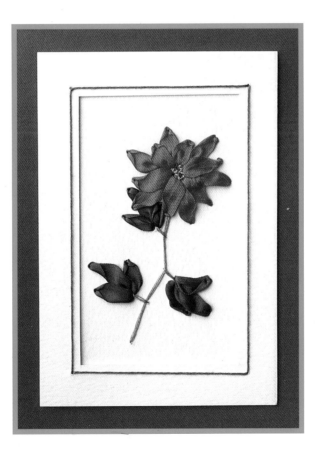

SEARCH PRESS

1-27-06

First published in Great Britain 2005

Search Press Limited
Wellwood, North Farm Road,
Tunbridge Wells, Kent TN2 3DR

ISBN 1 84448 049 6

The Publishers and author can accept no responsibility for any consequences arising from the information, advice or instructions given in this publication.

Suppliers
If you have difficulty in obtaining any of the materials and equipment mentioned in this book, then please visit the Search Press website for details of suppliers: www.searchpress.com

Alternatively, you can write to the Publishers at the address above, for a current list of stockists, including firms who operate a mail-order service.

> **Publishers' note**
> All the step-by-step photographs in this book feature the author, Ann Cox, demonstrating how to make silk ribbon greetings cards. No models have been used.

Cover

A Single Sunflower

To capture that late summer colour, this card is worked using 4mm (¹/₈in) wide silk ribbon in two shades of gold: gold (54) and deep gold (55).

Page 1

Poinsettia

The flower was embroidered through card, then mounted on a second card panel before adding the fine green thread edge. The template is on page 46.

Manufactured by Universal Graphics Pte Ltd, Singapore

Printed in Malaysia by Times Offset (M) Sdn Bhd

For my four super grandchildren: Christian Wall, Alexandria, Rebecca and Victoria Edwards.

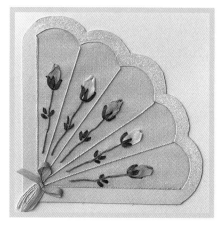

ACKNOWLEDGEMENTS

I need to say a very big thank you to my husband, Ashley, for his endless support, encouragement and maybe more importantly the super cook he has turned out to be; I raise my glass to him. Also to June and Maurie Salter, two very dear friends who helped more than they realised with the occasional flower that disappeared from their beautiful garden.

A special thank you to all the staff at Search Press, in particular to Editorial Director, Roz Dace, my editors John Dalton and Sophie Kersey for their attention to detail and Juan Hayward for his creative design skills.
To Benno White and Roddy Paine at Roddy Paine Photographic Studios for their photographic skills.

Last but certainly not least my students, wherever you may be – your enthusiasm and the ideas that inspire you are the constant challenge that keeps me on my toes. Thank you and happy sewing.

Opposite

Three Fuchsias

Life-size fuchsias have been embroidered through card in a variety of shades.

Contents

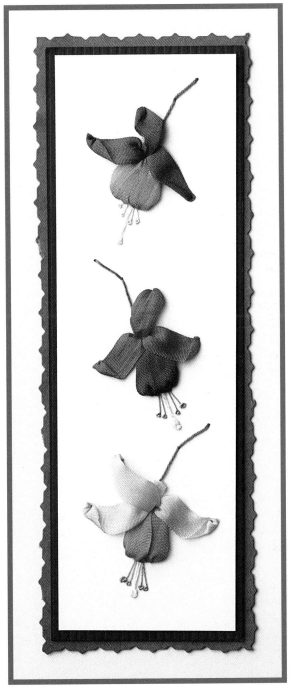

Introduction

Experimenting and developing new ideas is enormous fun, but when I started this book I had absolutely no idea the hours of pleasure I would have doing it. I was allowed to develop ideas and techniques from silk ribbon embroidery and simplify the methods of working to make them suitable for card making. The projects are small and therefore quick to work, so why spend hours searching for a card with that extra something when you can create one that is original and really personal?

First and foremost I am a silk ribbon embroidery designer and without doubt this is my first love. I only work with silk – its characteristics make it easy and quick for the embroiderer to shape each individual stitch. The only stitches I have worked for the cards in this book are ribbon stitch, straight stitch, lazy daisy stitch and gathering stitch in ribbon and couching and fly stitch in thread, but I have used new and different techniques to create this wide variety of flowers for you to choose from. All of these cards work on both fabric and card and you do not need to use an embroidery hoop. I also show you how to paint the ribbon to increase the range of flowers that can be worked.

At the start, make sure you have an envelope to fit the finished card. It is infuriating when finished to find there is no envelope to fit. Keep the project simple – avoid having too many fussy bits and pieces and above all keep the work impeccably clean.

As you turn the pages of this book I hope you will be tempted. There are lots of new ideas and techniques to make card making easier and give a more professional finish. Use these ideas and never be afraid to experiment to create your own original cards.

Happy sewing!

Thread stitches

Couching: A single strand of toning thread is used to secure another thread in place. This is useful when working curved stems.

Fly stitch: This is a single open looped stitch similar to a lazy daisy stitch. It is often worked as a calyx for flowers such as rosebuds.

Opposite
A selection of the beautiful cards that can be made by embroidering with silk ribbon without using an embroidery hoop.

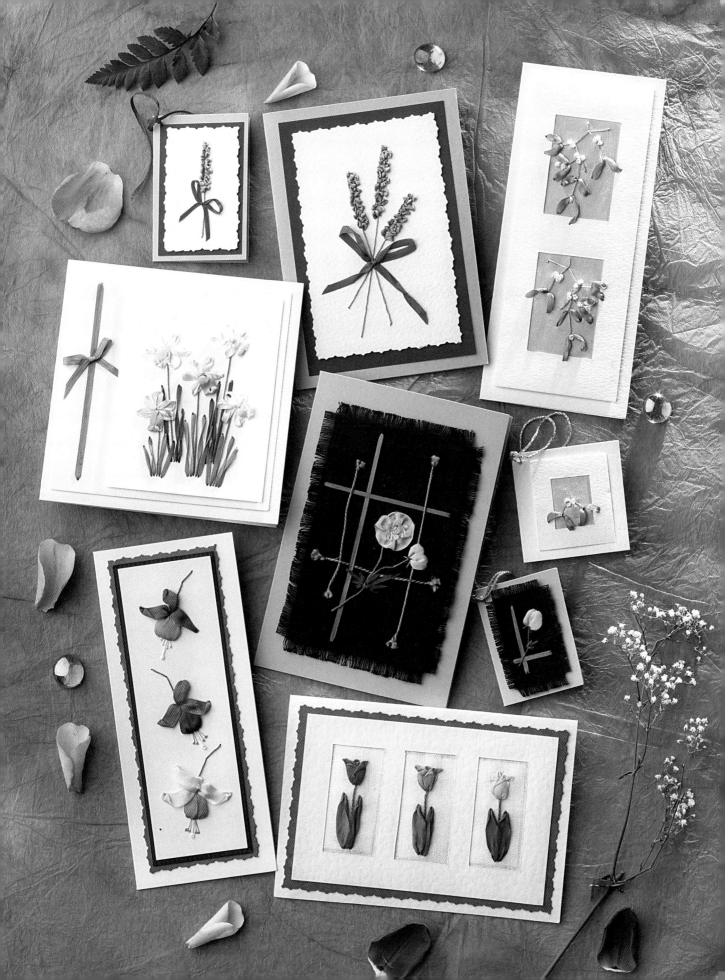

Materials

Silk ribbons

Pure silk is soft and fine, and when woven into ribbon, it allows the embroiderer to create stitches that are quite unique – impossible to obtain using any other fibre. Working with short lengths – no more than 33cm (13in) – the ribbon is threaded on to a needle and stitched using traditional embroidery stitches just like an embroidery thread. Ribbon is available in four widths: 2mm ($^1/_{16}$in), 4mm ($^1/_8$in), 7mm ($^1/_4$in) and 13mm ($^1/_2$in). Every stitch worked in ribbon will cover a much bigger area than a thread stitch. Ribbon is perfect for working through card as well as fabric. Silk is a natural fibre, making it easy to paint both before and after it has been embroidered to add a subtle depth and quality to the work. Never waste off-cuts; 5cm (1in) of ribbon will make a rosebud or leaf, and it may be just the shade you need to finish a project.

Needles and pins stored in a piece of sponge, on a foam mat used for pricking.

Pins and needles

Chenille needles with their sharp point and large eye are used to embroider silk ribbon and the size of needle used is critical. The hole made must be large enough for the ribbon to pass through without damaging the silk but small enough to allow control of the ribbon on the front. The largest size 13 needle is used for 13mm ($^1/_2$in) ribbon, size 18 for both 7mm ($^1/_4$in) and 4mm ($^1/_8$in), a small size 24 for the 2mm ($^1/_{16}$in) ribbon and a crewel size 8 for embroidery threads. A mapping pin and a few glass-headed pins are also needed.

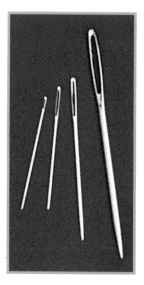

Card and fabric

Card and fabric can be smooth, textured, matt or shiny. Both are available in a limitless variety of colours, sometimes a single colour, sometimes shadowed or patterned. Whichever fabric you choose, it needs to be firm and not too loose a weave, since only small pieces are used and the fabric must be able to support the stitches. Avoid thick fabric as it will create too much bulk in the card. Choose card and/or fabric backgrounds to complement each other and the embroidery and avoid creating a 'busy' card with too many textures and colours.

To make life easy, store card on its end so that it is easy to pick a colour and keep all card off-cuts the same way, but in a separate box. Collect interesting pieces of fabric, no matter how small, but keep them flat.

Tip
When cutting card, place it on a different coloured card, as this will show up the cutting edge.

Card and fabric suitable for silk ribbon embroidery.

Silk painting equipment

Lightly painting a ribbon to alter the tone will bring the finished piece to life. I use silk paint, which is washable if iron fixed, to shade the ribbons and frequently the background fabric. I mix all colours on a kitchen tile from only yellow, blue, red and magenta paints. Paints can be applied using brushes or sponges, or the ribbon can be dropped in the paint on the tile for a patchy effect. I use watercolours to paint card and also at times background fabric, since you will not need to wash a greetings card so colour-fastness is not an issue.

Watercolour paints, silk paints, brushes, a kitchen tile for mixing, a sponge, sponge-painted card and a natural sponge.

Threads

You will need a selection of stranded embroidery threads to anchor ribbons to the fabric, to make a frame for the embroidery or for gathering. Metallic threads can add something special to a design. The small running stitches used to gather ribbon should always match the colour of the ribbon. I also like to use coton à broder or cotton perle in a mixture of greens and a variety of thicknesses for stitching stems. Garden string can be used to create the branches of trees for some designs.

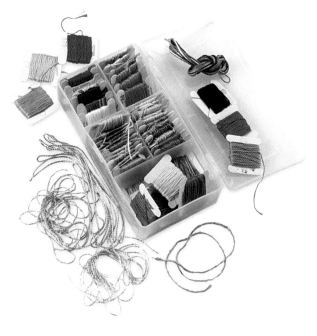

Other materials

I cut all my own cards to the size I require and a good craft knife, preferably with a retractable blade, is essential. Always use a cutting mat or board to prevent damage to work surfaces and blunting the blade and use a small foam mat on which to prick through designs. You will also need a metal ruler, a plastic ruler, a fine sharp pencil, small sharp scissors, paper scissors, a knitting needle, glue stick, a little PVA glue, a small pot of water with a lid to clean brushes, and some kitchen towel. A good quality paper trimmer, not essential but extremely useful, will enable you to cut card accurately and quickly, giving you more time for the fun part of card making. Similarly a pair of fancy-edged scissors will increase the range of finishes you can achieve, as will some glitter.

A pot of water, PVA glue, tweezers, a cutting mat, metal ruler, adhesive putty, glue stick, knitting needle, craft knife, pencil, eraser, syringe for silicone sealant, kitchen paper, fancy-edged, paper and fine scissors and glitter dust.

Silicone sealant

A card is often given an added quality if the embroidery is slightly raised from the base card and to do this I use a clear silicone sealant, available in most hardware stores. It is economical to buy and easy to use. I fill a small syringe so that I can position fine lines easily, and they dry quickly and without any mess. When it is not in use, cover the end with a small piece of adhesive putty to prevent the silicone solidifying in the syringe. Should this happen, either use a needle or tweezers to pull the solid piece out of the end or pull out the plunger and use a small spatula to remove the silicone. Small tubes of silicone are available but I find they produce far too much sealant at a time.

Below: silicone sealant in a gun, as it is bought from hardware stores.

Single Rose

This single rose, worked in 7mm (¼in) silk ribbon is a perfect project for your first card. It can be worked in any colour you choose, but using the two shades: pink (08) and pale pink (05) as I have here will bring the rose to life.

The techniques you will be guided through form the basis for many other cards as well. You will learn how to cut the card and secure fabric in the aperture so that no embroidery hoop is needed. I also show you a quick and easy way to anchor the ribbon (for card making only) and how, with care, to embroider perfect petals to create a rose. Finally there are the vital finer points such as the thorns and kinking the stem, the bow and assembling the card for that professional finish. Have fun and experiment: try changing the colour of the ribbons or card or the size of the aperture and soon every card you create will be unique – one for every occasion.

3 1833 04841 1810

You will need

Two sheets of red card, 26 x 13cm (10¼ x 5in) and 12cm (4¾in) square

Black linen, 5 x 11cm (2 x 4¼in)

Craft knife, cutting mat, metal ruler and knitting needle

Glue stick

Plastic ruler and pencil

Foam mat

Glass-headed pins and a mapping pin

Needles: two size 18 (medium) chenille for ribbons; a crewel size 8 for embroidery threads

7mm (¼in) silk ribbon: 25cm (10in) each of pink (08), pale pink (05) and deep moss (72)

4mm (⅛in) silk ribbon: 25cm (10in) each of pale pink (05) and deep moss (72)

Toning stranded embroidery threads

Clear silicone sealant

Tip

Always cut silk ribbon at an angle to prevent fraying and make threading a needle easier.

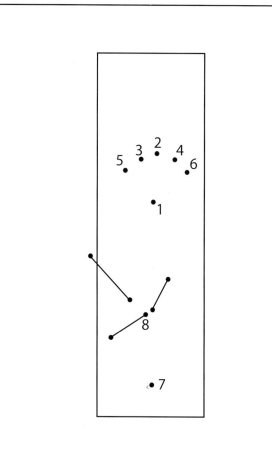

The pattern for the Single Rose card. Photocopy it to make a template.

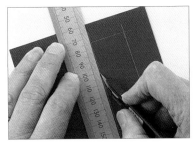

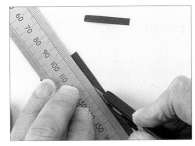

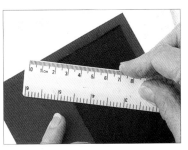

1. Use a metal ruler and a knitting needle to score and fold the red card in half. Measure and draw a 2.9 x 9.6cm (1⅛ x 3¾in) aperture in the single square of red card. Cut it out using a craft knife and cutting mat.

2. Reduce the width and length of the cutout panel by about 3mm (⅛in).

3. Working on the back of the red card square, apply glue stick round the aperture, taking care not to get glue on the cut edges. Lay the black linen over it and stretch it over the aperture by passing a plastic ruler across the fabric.

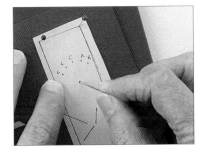

4. Place the card face up on the foam mat and use glass-headed pins to fix the template over the aperture.

5. Now use a size 18 chenille needle to prick through the dots on the template.

The holes made in the linen by the needle in step 5 are clearly visible. It is not necessary to mark them with chalk as this is such a small project.

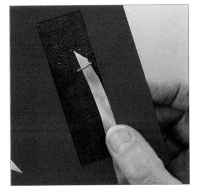

6. Thread the 7mm (¼in) pink ribbon on the needle, then, working on the right side, take the tail end down through hole 1 in the fabric.

7. Always anchor ribbon on the wrong side behind the stitch to be worked, and when finishing off. Apply a little glue stick to the back of the fabric and use a glass-headed pin to smooth down the tail end of the ribbon to secure it.

Tip

Using the eye end of another needle, stroke the underside of the ribbon to straighten and position it before stitching.

11

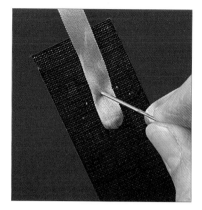 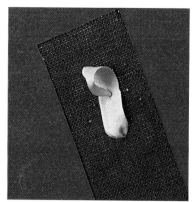 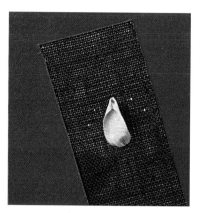

8. Turn the card face up, lay the ribbon (with a slight lift) over hole 2, then take the needle and ribbon down through the centre of the ribbon and hole 2.

9. Start to pull the ribbon carefully through itself and the fabric...

10. . . . until the petal is formed. Do not pull it too tight or the shape will be lost. This is centre ribbon stitch.

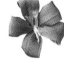

Tip
To shape the petals, use the eye of a second needle the same size as the one used to embroider the ribbon.

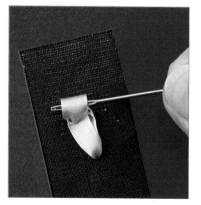 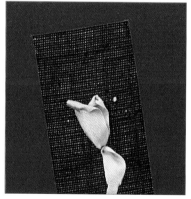 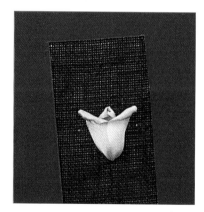

11. Bring the ribbon up carefully at 1 and lay it over the first stitch but this time take the needle down through the left-hand edge of the ribbon at 3 and place the eye end of a second needle in the loop to pull the ribbon over. This is a left ribbon stitch.

12. Pull the ribbon firmly over this needle, keeping it in place. Bring the first needle up again at 1 then remove the second needle.

13. Repeat steps 11 and 12 for the third petal, but this time take the needle down through the right-hand edge of the ribbon at 4. This is a right ribbon stitch. Fasten off at the back with a touch of the glue stick as before.

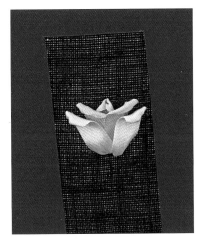

14. Anchor a length of 7mm (¼in) pale pink ribbon at 1, lay the ribbon over the left petal, then work a left ribbon stitch at 5 and a right ribbon stitch at 6. Fasten off as before.

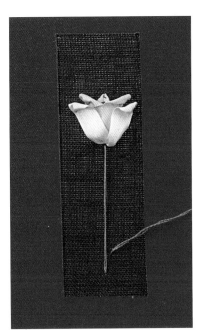

15. Using two strands of green embroidery thread and a crewel size 8 needle, work a straight stitch stem, coming up at 1 and down at 7. Bring the thread up just to the right-hand side of the stem, 7mm (¼in) up from the bottom.

Tip

Avoid bringing the needle up through ribbon on the back of the work, as it will destroy the stitches previously worked.

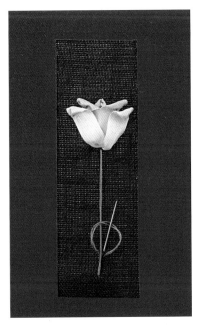

16. Take the thread over then under the stem and back down the same hole to make a loop. Now bring the needle back up through the loop.

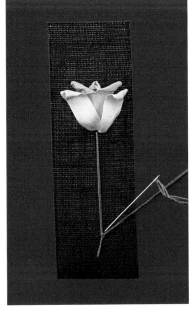

17. Pull the stitch tight to create a thorn and a kink in the stem, then take the needle down to make a tiny chain stitch and complete the stitch.

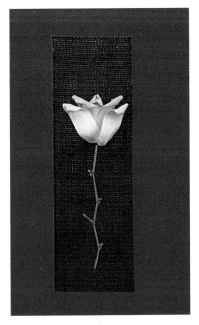

18. Next work a short straight stitch to create a leaf spur, then add two more thorns up the stem.

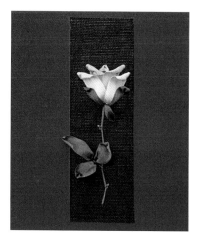

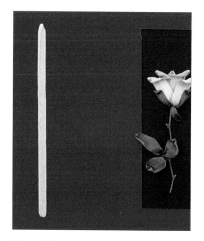

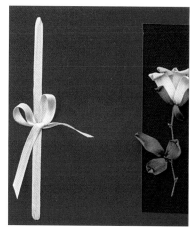

19. Using 4mm (⅛in) deep moss ribbon, work a left, right and centre ribbon stitch to form the calyx. Anchor the 7mm (¼in) deep moss ribbon at 8 and work three centre ribbon stitches to form the leaves. Work the middle leaf through the card as shown.

Tip
The piece of card fixed behind the aperture takes up the tension of the fabric and should be added to all cards with fabric in an aperture.

20. Use a mapping pin to make two holes in the card 15mm (⅝in) from the left-hand side, 6mm (⁷⁄₁₆in) down from the top and up from the bottom. Use the 4mm (⅛in) pale pink ribbon to lay in a straight stitch, anchoring each end on the back of the card with a touch of glue stick.

21. Tie a bow with the rest of the 4mm (⅛in) pale pink ribbon, then use a single strand of pink thread to anchor the bow through the ribbon and the card.

Tip
It is easier to position a bow with streamers if it is tied separately and then anchored with a thread.

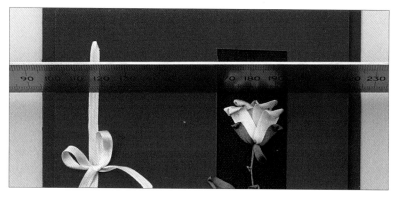

22. Glue the small piece of red card from step 2 on the back of the embroidery, then apply strips of silicone sealant as shown.

23. Place the embroidered panel neatly in the centre of the folded card blank, then use a ruler to level the card on the sealant. The sealant will ensure that the panel sticks firmly to the card but is slightly raised from it.

The finished card. This is a beautiful greetings card, just perfect for any special occasion. You could change the colours of the rose and card, maybe to match a bride's colours or a particular anniversary. You could also use the design to make a box of notelets, place name cards for a dinner party, a panel to go on the top of a pretty box or a gift tag as shown below.

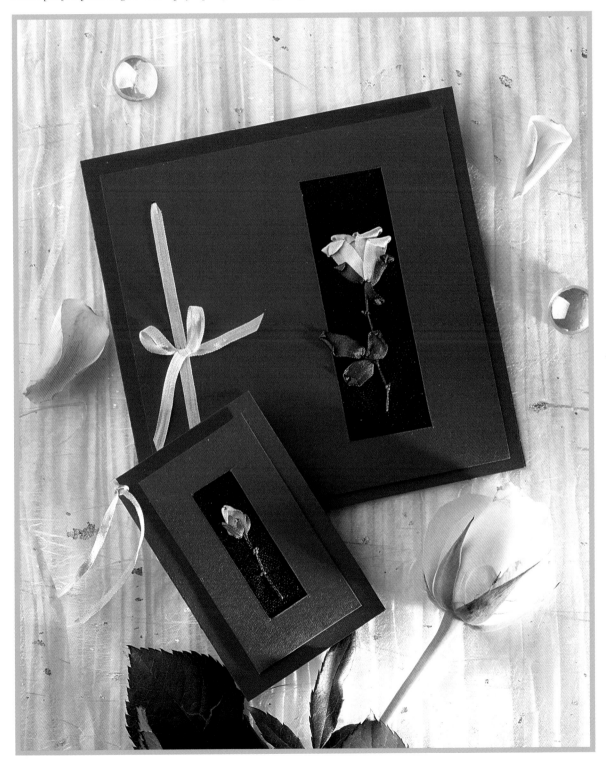

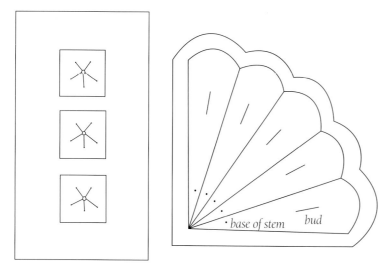

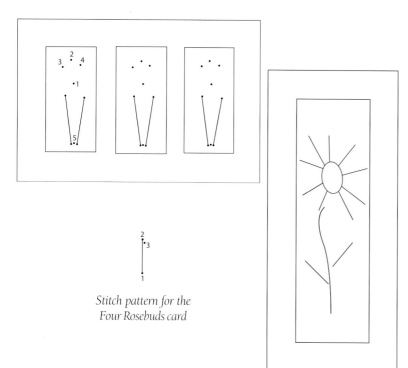

base of stem bud

Stitch pattern for the
Four Rosebuds card

These templates for the cards shown opposite are all printed half
size, so you will need to enlarge them 100% on a photocopier.

Clockwise from top left:

Violas

These tiny pansies are centre ribbon stitches worked in 7mm (¼in) ribbon. Work the two top petals first, then the lower three. Use a second needle as in step 11 to create the round petal shape. Using 4mm (⅛in) pale yellow ribbon, work a small straight stitch over the lower three petals and deep yellow to work a two-loop French knot into each centre.

Rosebud Fan

Pale green fabric is set into card cut into a fan shape with a green thread to divide the panels. Buds are centre ribbon stitches worked in 7mm (¼in) ribbon, and then mounted on to the card blank.

A Single Sunflower

The petals are ribbon stitches worked in two shades of 4mm (⅛in) ribbon. Using deep gold (55) work the petals round in order as indicated, then fasten off. Continue to work round, using gold (54) to work petals between those already worked. Using a thread each of sand, brown and black stranded cotton together, work two-loop French knots to fill the centre. Work a straight stitch stem with six strands of sand embroidery thread and a single thread to couch and curve it in position. Add two 7mm (¼in) green ribbon stitch leaves to complete.

Four Rosebuds

The buds are worked on a piece of black linen on the straight of the grain, then cut to size and the the edges fringed. Using 7mm (¼in) ribbon, work a centre ribbon stitch and then a right ribbon stitch directly over the top. See step 19 to work the calyx in 2mm (¹⁄₁₆in) green ribbon.

A Trio of Tulips

The tulips are worked with 7mm (¼in) ribbon in yellow (15), orange (40) and red (02). Refer to steps 1–13 and 15 to prepare the card and embroider the flowers and stems. Anchor a length of green 7mm (¼in) ribbon at the base of a stem and work a ribbon stitch leaf. Fasten off. Work each leaf in turn. I have glued a coloured card behind the embroidered card to highlight it.

Tip

Stitch petals in order round a centre. Never take the ribbon across the centre of a flower at the back, as it will cause problems when stitching through it.

Lilac Garland

Straight stitch loops may be worked in many different ways to great effect. Flowers with several petals are worked through fabric placed behind a shaped aperture to support the stitches, whilst single flowers like delphiniums are worked through card only. Different width ribbons increase the variety of flowers and working with two different shades of the same colour will bring a design to life.

It is the very simplicity of the design that creates this delicate card. Worked in blue and pink it would make forget-me-nots, but I have chosen two shades of mauve to work a garland of lilac blossom.

You will need

Lilac single-fold card blank, 13cm (5in) square

Lilac card, 11cm (4¼in) square

White fabric, 9.5cm (3¾in) square

Fancy-edged scissors

Knitting needle

Glue stick

Mapping pin

Foam mat

Needles: two size 18 (medium) chenille and a crewel size 8

Green coton à broder

4mm (¹⁄₈in) silk ribbon: 50cm (20in) each of deep mauve (179), light mauve (178) and just blue (100)

Deep pink embroidery thread

Clear silicone sealant

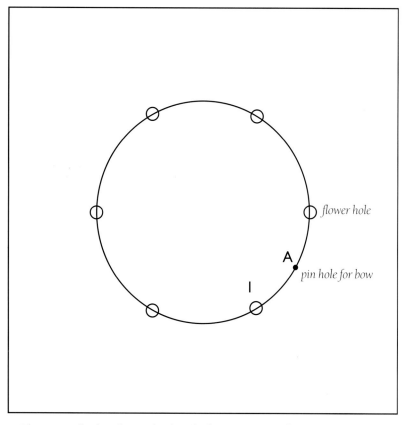

The pattern for the Lilac Garland card. Photocopy it to make a template.

Within the diagram: *flower hole*, A, *pin hole for bow*, I

Tip

Tension is critical when you are creating any petal shape. Always pull the ribbon gently through the fabric. Pull too tightly and the shape is lost, but if you pull too loosely it will make a loop rather than a petal. Take your time when you first work a new stitch or technique.

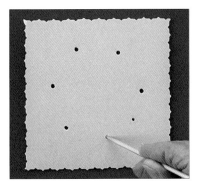

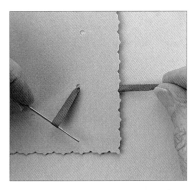

1. Trim the piece of card to a 10cm (4in) square with fancy-edged scissors. Use a mapping pin and a foam mat to transfer the design on to the card from the template and then a knitting needle to enlarge the six holes for the flowers.

2. Secure the fabric on the back of the panel with a glue stick. Referring to page 11 steps 6 and 7, anchor the tail end of deep mauve ribbon at hole 1, then take the needle up and back down through this hole to form a loop.

3. Use the eye of a second needle to keep the ribbon flat and the loop tight as the ribbon is pulled through to the back.

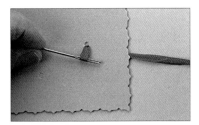

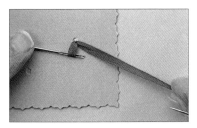

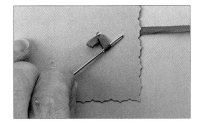

4. Continue pulling the ribbon until the loop is small enough to form a petal about 8mm (5/16in) long.

5. Without removing the second needle, bring the ribbon up through the fabric close to the side of the first stitch.

6. Work a second petal in a similar manner to the first.

7. Complete the first flower by making three more petals, then anchor the end of the ribbon on the back of the panel with a glue stick.

8. Work the other five flowers in a similar manner, alternating between light and deep mauve ribbon.

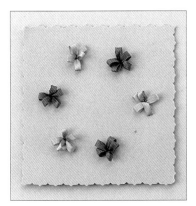

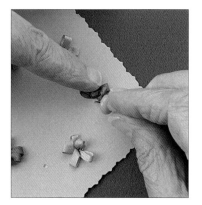

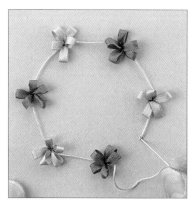

10. Bring a length of green coton à broder up at A, leaving a 7.5cm (3in) tail on the underside, and work a straight stitch between each flower to form the circular shape of the garland. Take the thread back down at A and tie the ends together to secure them.

9. Use the mapping pin to make a hole through the card on either side of each flower, about 3mm (1/8in) away from the original holes.

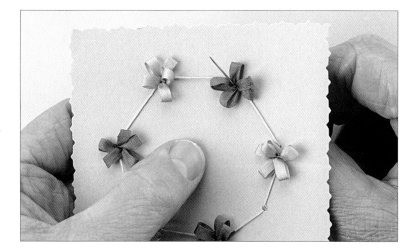

11. Use two strands of deep pink embroidery thread to work a French knot in the centre of each flower. Start by bringing the needle up through the centre of the flower.

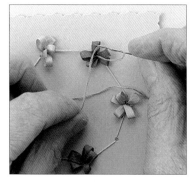

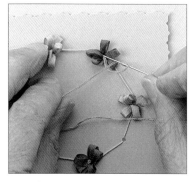

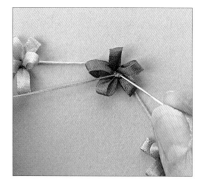

12. Pull the thread through, then wind the thread twice round the needle.

13. Take the needle back down through the centre of the flower.

14. Pull the knot tight and keep this thread taut as the needle and thread are pulled through to the back.

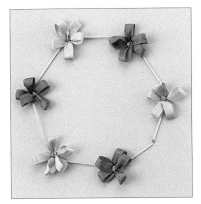 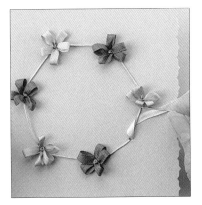 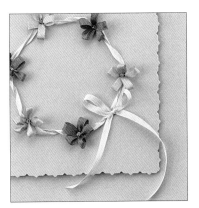

15. Continue round the garland, working a French knot in the centre of each of the other five flowers.

16. Anchor the tail end of the just blue ribbon at A, then wrap the ribbon once round the green thread before taking it down through the hole adjacent to the first flower.

17. Continue winding the ribbon round the garland, then take it back down at A. Tie a bow with the remainder of the ribbon and secure it at A. Attach the panel to the front of the folded card blank using clear silicone.

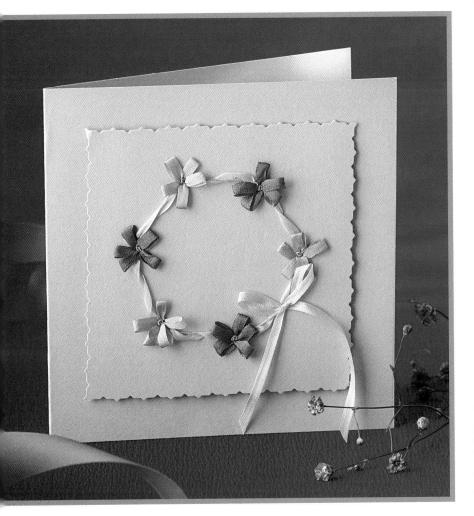

The finished card. This is a very pretty, dainty card and would look delightful worked in any combination of colours. You could even alter the shape – it could be a letter, number or a heart shape instead of a circle.

start/finish

centre drawn on fabric

hole

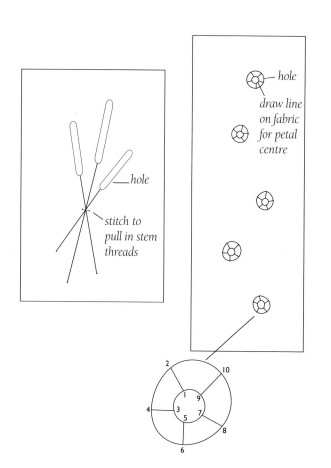

hole

draw line on fabric for petal centre

hole

stitch to pull in stem threads

2 10
1 9
4 3 7
5
8
6

Clockwise from top left:

Apricot Heart

The flower is worked with 7mm (¼in) ribbon in deep salmon (122) with a bead in the centre and three straight stitch leaves worked each side.

Delphiniums

These delphiniums worked with 7mm (¼in) pale blue (125) ribbon are straight stitch loops worked from side to side up the stem. Two threads are used to work a two-loop French knot up through the centre of each flower to pull the loop down to the fabric.

Clematis Garland

Two shades, deep pink (128) and dusky red (114) 7mm (¼in) ribbon are used to work the five straight stitch looped petals. Using three strands of yellow thread, work a series of loops in each centre, anchor off then cut the loops. Couch the stem to curve below each flower then use 4mm (⅛in) moss green (20) ribbon to work the straight stitch leaves.

Lavender Spray

Tiny straight stitch loops are worked alternately (not in pairs) in two rows up each aperture to the tip of the flower. The straight stitch stems are pulled in, to secure, before adding the bow.

Daisies

The daisies, worked with 2mm (¹⁄₁₆in) ribbon are straight stitch loops. Centre holes 0.5cm (³⁄₁₆in) across are cut at intervals and the centres are filled with two-loop French knots using a strand each of yellow and pale green embroidery thread. The loops are then cut to form the petals.

These templates for the cards shown opposite are all printed half size, so you will need to enlarge them 100% on a photocopier. You will not need a template for the Daisies card.

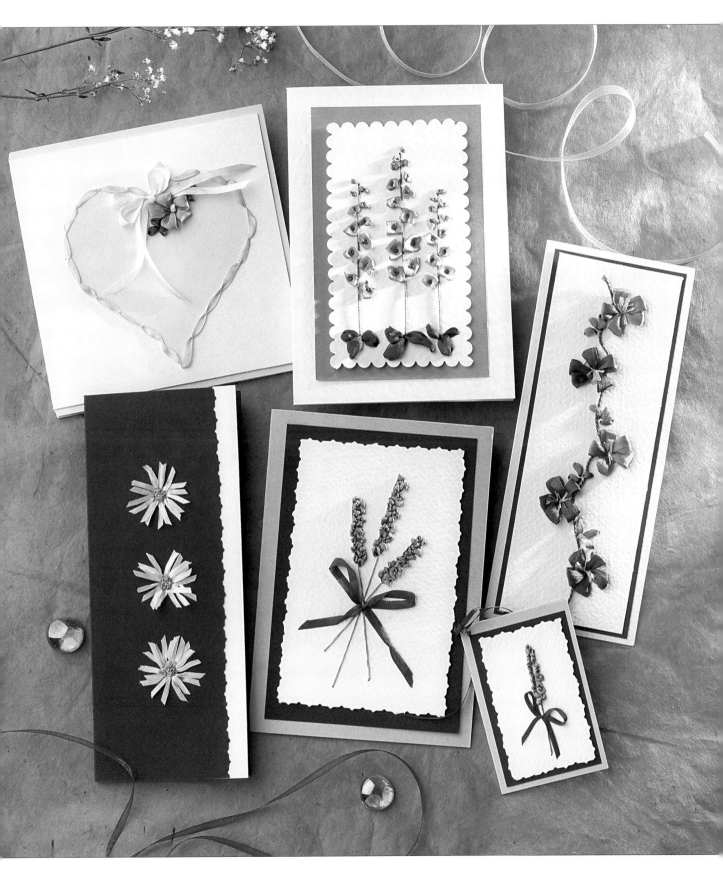

Fuchsias

Silk ribbon gathered with a row of tiny running stitches is used to create a completely different range of flowers. The flowers will vary depending on the width of ribbon used, the length gathered and of course the colour. These fuchsias are delightful and by using a little paint, you can transform them.

You will need

Single-fold white card blank, 10.5 x 15cm (4⅛ x 6in)

White card, 8.5 x 12cm (3¼ x 4¾in)

White fabric, 8cm (3⅛in) square

Glass-headed pin, mapping pin and foam mat

Craft knife and cutting mat

Glue stick

Silk paints: red, magenta and yellow

Paintbrushes, tile, kitchen sponge and an iron

Needles: a size 13 (extra large) and two size 18 (medium) chenille and a crewel size 8

13mm (½in) silk ribbon: 50cm (20in) of pale pink (05)

7mm (¼in) silk ribbon: 50cm (20in) of dusky red (114) 25cm (10in) of deep green (21)

4mm (⅛in) silk ribbon: 50cm (20in) of dusky red (114) 25cm (10in) of deep green (21)

Toning stranded embroidery thread and green coton à broder

Scissors and tweezers

Clear silicone sealant

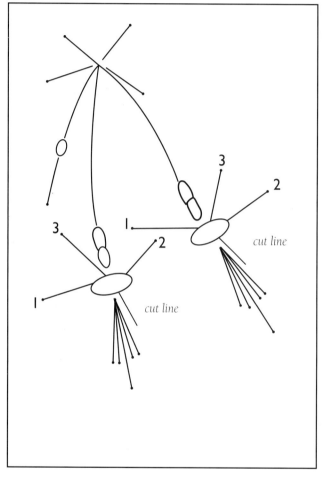

The pattern for the Fuchsias card. Photocopy it to make a template.

1. Use the template, a glass-headed pin, a mapping pin and a foam mat to transfer the design on to the piece of white card.

Tip

Gathered flowers are worked using short lengths of ribbon – a perfect way to use up your odds and ends. Always use a toning thread to gather ribbon.

24

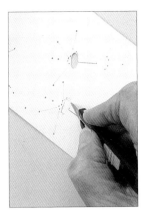

2. Use the craft knife to cut round the oval shapes where the flower petals will sit.

3. Use a glue stick to stick the white fabric on the back of the card.

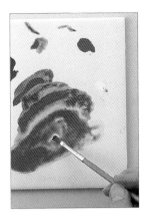

4. Mix the red, magenta and yellow silk paints on the tile to create the colour for the fuchsia.

5. Pin one end of the 13mm (½in) pale pink ribbon to the kitchen sponge, then use a paintbrush to wet the ribbon.

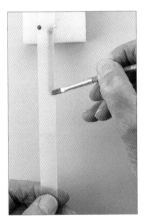

6. Use a small brush to apply colour to one side of the ribbon. Note how it spreads across the ribbon.

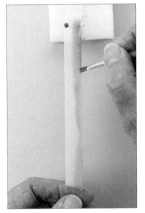

7. Add more colour down the selvedge of the ribbon and hang it up to dry. Iron the ribbon to set the silk paint.

Tip
Silk dries very quickly, but if you wish to speed up the process, a hairdryer is useful. It will also stop paint from spreading too far if too much has been used on either ribbon or fabric.

8. Knot the end of a strand of toning thread and take it through one end of the painted ribbon, 1cm (³/₈in) from the tail end, on the pale edge. Make a stitch over the edge to anchor the thread to the selvedge.

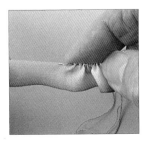

9. Start to work tiny running stitches along the selvedge.

10. Work a 10cm (4in) length of running stitch, then trim the ribbon diagonally 1cm (³/₈in) from the last stitch. Do not cut the thread.

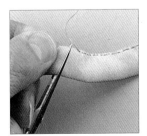

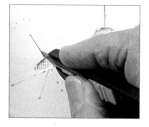

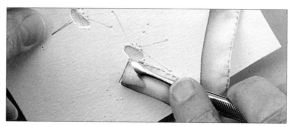

11. Use a craft knife and cutting mat to cut a slot through the card and fabric below each oval.

12. Use the flat end of a pair of tweezers to push the knotted end of the ribbon through the slot in the right-hand flower, with the stitched edge nearest the centre.

13. On the back of the panel, adjust the angle of the ribbon in the slot so that it is parallel to the cut end. Secure the tail with glue.

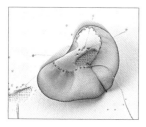

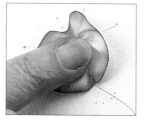

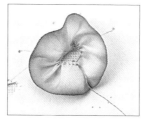

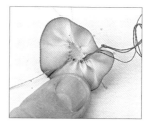

14. Pull the running stitch thread slightly to start the gather, then repeat steps 12 and 13 to secure the other end of the ribbon. The running stitch thread must stay on top.

15. Place a finger in the centre of the loop of ribbon, then gently pull the running stitch to gather the selvedge.

16. Keep checking the size of the gathered loop until it fits the edge of the cutout oval shape.

17. Using a toning thread, work in stab stitch along the gathered edge from the knotted end around to the right-hand end of the oval, tight to the card.

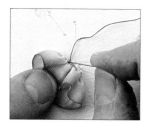

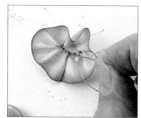

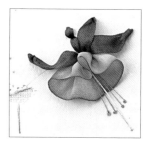

18. Fold the top of the gathered ribbon down, then stab stitch the selvedge, tight to the card, across the top of the oval.

19. Open up the gathered ribbon and stab stitch the left-hand side of the bottom of the oval. Take the working thread and the gathering stitch thread to the back of the panel and tie off both.

20. Using 7mm (¼in) dusky red ribbon, work a loose ribbon stitch over the frill, taking the needle down through the top edge of the ribbon at 1. Repeat for petal 2 and work a centre ribbon stitch at 3. Then use 4mm (⅛in) ribbon the same colour to work the straight stitch tube. Add a tiny 4mm (⅛in) deep green stitch at the top. Use pink and white embroidery thread to work straight stitches with French knots (see page 38) at the ends to form the stamens.

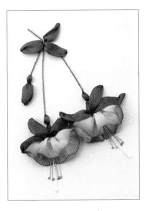

21. Work the second flower in the same way, then add a straight stitch bud. The stems are coton à broder straight stitches and the leaves are ribbon stitch using 7mm (¼in) deep green ribbon.

The finished card

I attached the panel to the folded card blank using clear silicone sealant as described on page 14. When it was dry, I used a 4mm (⅛in) dusky red ribbon to highlight the design, using the following method. Use a mapping pin to make holes in three corners of the card front and in the bow position as shown. Tie a small looped bow in the centre of the ribbon and pull the knot tight. Leaving a long end at the back, anchor the bow in position with a stitch in a toning thread, then use this thread to work a stitch to anchor the ribbon at the corner. Now tie off the ends to secure them. Keep the ribbon flat on the front and, referring to page 11 steps 6 and 7, anchor the ends on the back of the card.

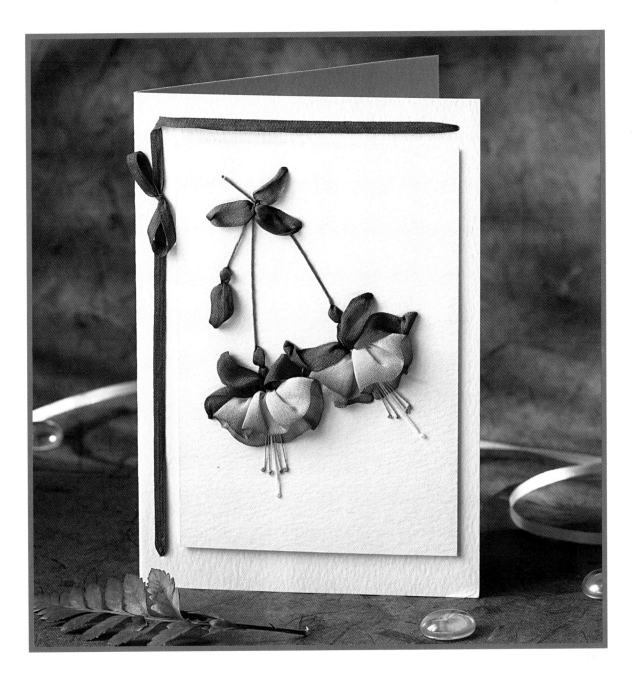

aperture

decorative
thread edge
through card

These templates for the cards shown opposite are all printed
half size, so you will need to enlarge them 100% on a
photocopier. You will not need a template for the left-hand
panel of the Scabious Garland card.

Clockwise from bottom left:

Poppies

Using red (02) 7mm (¼in) ribbon, gather
four 6cm (2¼in) lengths, plus a 1cm (⅜in)
tail at each end. Now proceed as in steps
8–16, but use a chenille size 18 needle to
take the ribbon through the card. Gather the
ribbon evenly round the aperture, stab stitch
it in place and using two black threads, fill
the centres with two-loop French knots. Work
straight stitch buds with 7mm (¼in) moss
green (20) ribbon and add a straight stitch
stem, couching through the card with a
toning thread to curve it. Use this thread to
work the fly stitch leaves.

Bowl of Anemones

Glue pale green fabric in the aperture and
cut out the bowl shape. See page 37 steps 7
and 8 to shape and position. Work the flowers
as for the poppies using 7mm (¼in) ribbon in
deep pink (128), delph blue (117), deep red
(49) and purple (177), then work two-loop
French knots in black to fill the centres.
Using green coton à broder, work tiny fan
shapes for the leaves. Edge the card with two-
coloured threads.

Buttercup

Cut a piece of black linen on the straight of
the grain, fringe each side and press. Make
holes for flowers in a piece of card and stick it
behind the fabric but not the fringe, and
make holes for flowers. Work the flower and
bud (two stitches) as for the poppies with
7mm (¼in) yellow (15) ribbon, then the
stamens as for the clematis centres on page
22. Couch the two thread lines in position
and work the two straight stitches with 2mm
(¹⁄₁₆in) moss green ribbon. Work the stem and
add leaves using 2mm (¹⁄₁₆in) green ribbon.

Scabious Garland

Prepare both white panels as in steps 2 and
3. Mix blue silk paint with a hint of magenta
to shade 66cm (26in) of 7mm (¼in) white
(03) ribbon patchily. Dry then press the
ribbon. Work as for the poppies but gather
seven 6cm (2¼in) lengths plus 1cm (⅜in)
tails and use a strand each of pale green and
yellow for the centres. Work the stem and
leaves as for the garland on page 21.

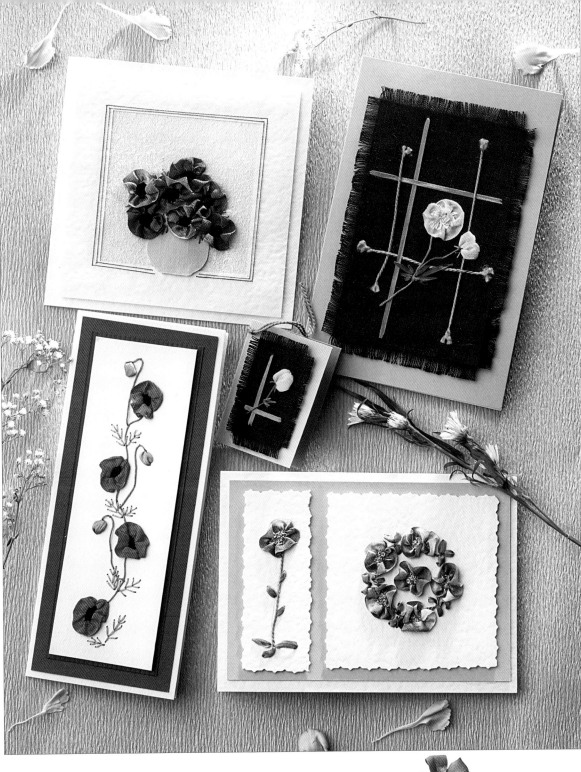

Tip

To make an edging as in the Bowl of Anemones card: make a pinhole at each corner of the card, thread a needle with a coloured thread and take it down through a hole, leaving half of the thread at the front. Lay the top thread over the next hole and bring the needle up, over and back down to hold this thread. Keeping the top thread taut, work the next two corners, unthread the needle and use it to take the top thread down at the start. Tie the ends off securely. Repeat with a second colour.

Three Irises

Lazy daisy stitches are perfect for the irises in this project and may be worked in any combination of colours.

Many flowers can be created by embroidering silk ribbon directly through card without the use of fabric. However, not all flowers can be worked this way, since the stitches need to be far apart, otherwise the card will collapse. Flowers with many petals worked to a centre must have a hole in the card with a piece of fabric at the back to support the stitches.

When I embroider directly into card, I always mount the embroidered card just above the base card using silicone, to add to the dramatic effect.

It is fun to have a session using off-cuts of card and pieces of silk ribbon. Experiment with different stitches and colours – the results will be useful if a card is needed in a hurry!

You will need

Red single-fold card blank, 14 x 10cm (5¾ x 4in)

White textured card, 15 x 10cm (6 x 4in)

Fancy-edged scissors

Glue stick

Mapping pin and foam mat

Needles: two size 18 (medium) chenille and one crewel size 8

Green coton à broder

4mm (⅛in) silk ribbon: 25cm (10in) each of purple (177), blue (117), red (02) and yellow (15) and 1m (39½in) of deep green (21)

Clear silicone sealant

The pattern for the Three Irises card. Photocopy it to make a template.

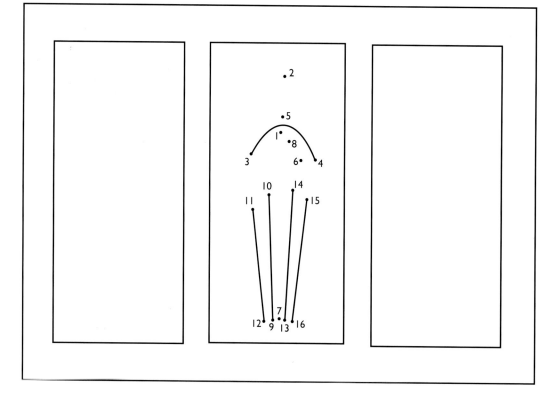

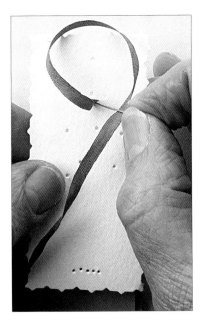

1. Use the fancy-edged scissors to cut three 3 x 8cm (1¼ x 3⅛in) panels from the white card. Use the mapping pin to transfer the design on to each panel. Working on the first panel, anchor the 4mm (⅛in) purple ribbon at 1 (see page 11 steps 6 and 7) then take the needle back down through 1 again.

2. Pull the ribbon through to leave a loop, not too tight, then bring the needle up at 2 and through the loop.

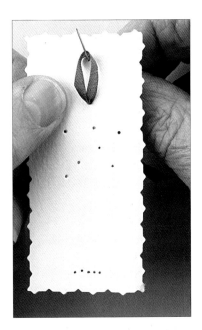

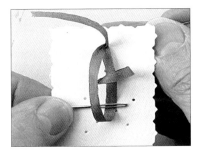

3. Pull the ribbon through. Take the needle over the loop and back down through at 2, using the eye end of a second needle to keep the ribbon flat.

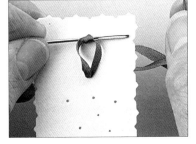

4. Pull the ribbon through, keeping the loop tight against the needle as it is pulled through, so that it spreads the loop and sits neatly over the top.

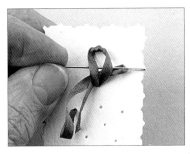

5. Remove the second needle, bring the ribbon up through 3, then use the eye end of the needle to take the ribbon under the first loop.

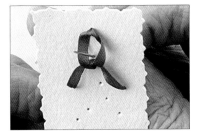

6. Take the ribbon down loosely through 4 and back up at 5. Be careful not to stitch through ribbon at the back.

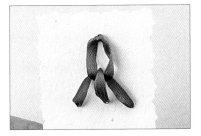

7. Pull the ribbon through then take it down through hole 6. Anchor the end and snip off any excess ribbon.

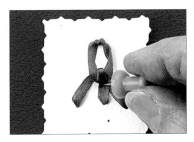

8. Use the mapping pin to make a new hole through the ribbon and card, one-third down the last loop.

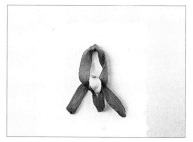

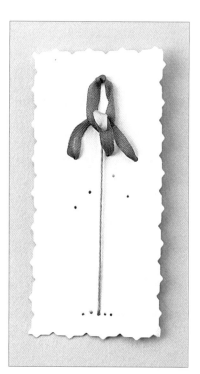

9. Bring the yellow ribbon up carefully at 5, then, using the eye end of a second needle under the purple ribbon loop to support it, take the yellow ribbon needle down through the purple ribbon and the new hole in the card.

10. Pull the ribbon through, trim off the excess and anchor the end on the back of the card.

11. Make a new hole 8, just below the centre and concealed behind a petal and work a straight stitch stem using green coton à broder, coming up at 7 and down at 8. Fasten off.

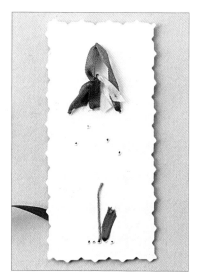

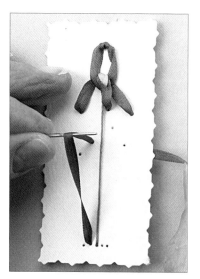

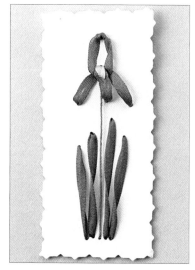

12. Anchor the green ribbon at 9 with a touch of glue.

13. Turn the card face up, re-thread the green ribbon and take it down at 10. Use the eye end of a second needle to create a twist in the ribbon and keep it tight over this needle as it is pulled through to the back.

14. Bring the ribbon up at 11 and then down at 12, adding a twist as in step 13. Continue working to make two more leaves from 13 to 14 and 15 to 16 then anchor the end on the back.

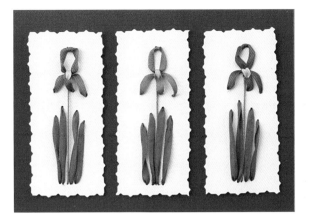

15. Now complete the other two panels, then use silicone to place the panels slightly raised on the red card blank.

The finished card with a matching gift tag. Irises come in every colour imaginable, in one shade as I have shown here or a combination of two colours. Try using a different tone or shade for the lower petals – experiment and have fun.

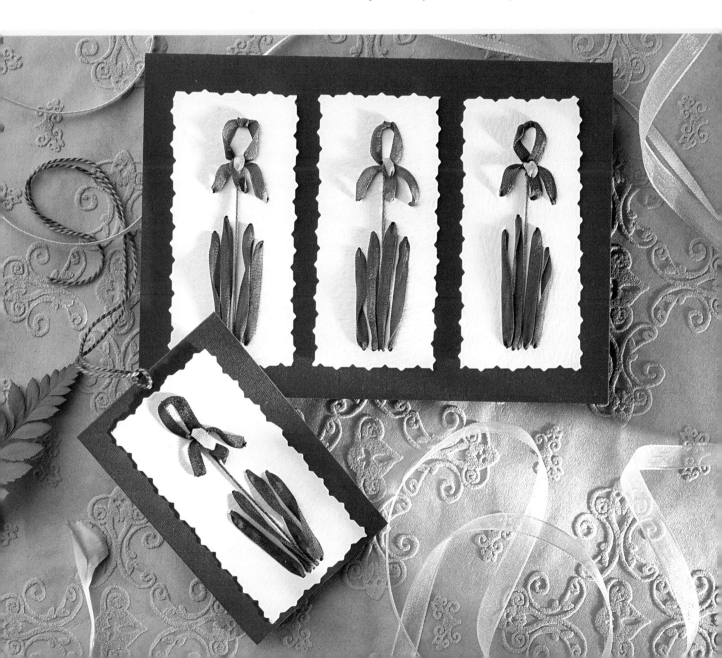

These templates for the cards shown opposite are all printed half size, so you will need to enlarge them 100% on a photocopier.

Clockwise from top left:

Daffodils

The petals are worked with 4mm(1/$_8$in) ribbon in pale yellow (13), yellow (15) and gold (54); the trumpets with 7mm (1/$_4$in) yellow and gold ribbon and the leaves with 2mm (1/$_{16}$in) moss green (20) and deep green (21) ribbon. Start with the back petals, anchor a yellow ribbon at 1 and a toning thread at the back. Bring the thread up at 2, lay the ribbon round the thread and take the thread over it and back down to hold the ribbon. Bring the needle up again at 1, secure the ribbon to complete the first petal, work the remaining petals, then fasten off. Use 7mm (1/$_4$in) yellow ribbon to work a centre ribbon stitch trumpet using a second needle as on page 12. Add stems and leaves.

Apple Blossom

Prepare the card and draw in the stem, then partially unravel a 5cm (2in) length of string and stick with PVA for branches. Using 7mm (1/$_4$in) pink (08) and pale pink (05) ribbon, work each straight stitch petal from the centre to the tip. Work ribbon stitch leaves in various greens with 4mm (1/$_8$in) and 7mm (1/$_4$in) ribbon. Use one black and five yellow threads to work the stamens.

Three Fuchsias

Using a mixture of 7mm (1/$_4$in) pinks (24, 25, 166), red (02) and mauve (177) ribbons, start at 1 and work the bell with two straight stitches. Now refer to page 26 steps 20 and 21 to complete the fuchsia.

Bluebells

Work the straight stitch stem and couch the top to curve. Flowers are two offset lazy daisy stitches with a few tiny straight stitch buds at the top. Start with the lowest and work up the stem. Use 4mm (1/$_8$in) moss green (20) ribbon for the straight stitch leaves.

Climbing Rosebuds

These rosebuds are tiny lazy daisy stitches using 4mm (1/$_8$in) dusky pink (163) ribbon. Avoid taking ribbon across the back of the work. Anchor off after each group of stitches is worked. Lay the stem on the surface and couch in position. With two strands of green thread, work a straight stitch from the centre to the base of a bud and then a fly stitch for the calyx. Work ribbon stitch leaves with 4mm (1/$_8$in) green ribbon.

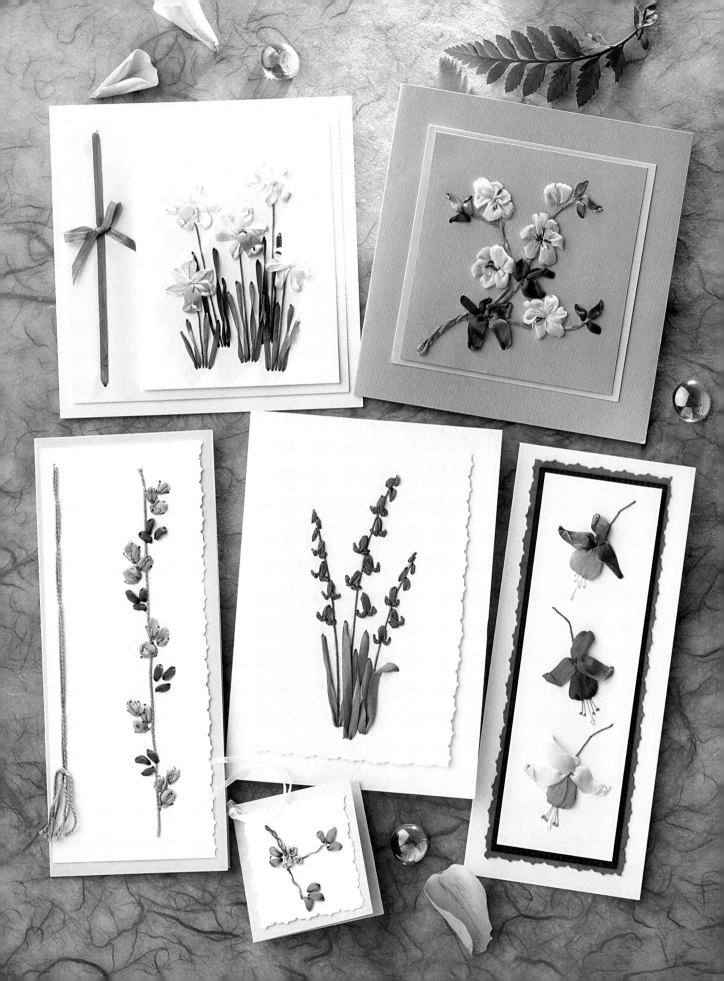

Window Box

French knots worked in all widths of ribbon are wonderful and here they are used to make hyacinths in a pot.

For this project I thought it might be fun to work some different ideas, ones that can be adapted and modified from projects on previous pages. I have cut out a window and sill with a row of pot plants. A similar design could be used to make bowls of flowers and you could make a door or gate instead of a window.

You will need
Mottled beige card blank,
16 x 10.5cm (6¼ x 4⅛in)

White hammered card,
14.5 x 9.5cm (5¾ x 3¾in)

White fabric, 13.5 x 8.5cm
(5¼ x 3¼in)

Off-cut of white card

Watercolour paints, blue and yellow silk paints, an iron, paintbrush, tile and natural sponge

Craft knife, metal ruler and cutting mat

Mapping pin and foam mat

Pencil and glue stick

Knitting needle and tweezers

Needles: two size 18 (medium) and one size 24 (small) chenille; one crewel size 8

Glass-headed pins

7mm (¼in) silk ribbon:
33cm (13in) of moss green (20)

4mm (¼in) silk ribbon:
66cm (26in) of deep blue (118)
50cm (20in) of delph blue (117)
50cm (20in) of deep salmon (43)
33cm (13in) of deep apricot (168) and
66cm (26in) of cream (156)

2mm (¹⁄₁₆in) silk ribbon:
33cm (13in) of deep green (21)

Green coton à broder and brown, salmon and pale green embroidery thread

Clear silicone sealant

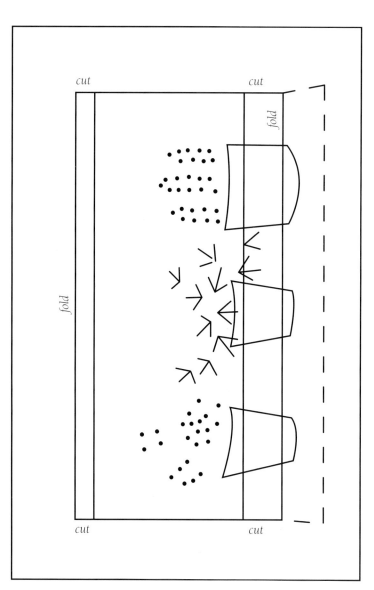

The pattern for the Window Box card, shown on its side. Photocopy it to make a template.

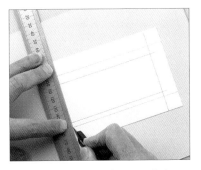

1. Transfer the shape of the window, awning and sill on to the wrong side of the white hammered card. Cut along the full length of the short sides of the window.

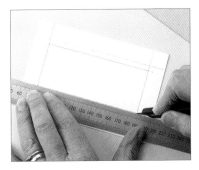

2. Now cut along the bottom of the awning and along the top of the sill.

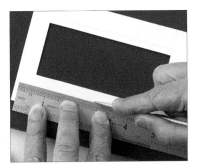

3. Place the card on to a foam mat, then use a knitting needle to score along the fold lines for the awning and sill.

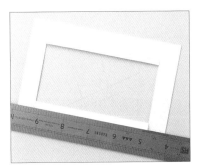

4. Turn the card face up and bend the awning up slightly. Apply a thin strip of silicone sealant under the sill, then bend the sill over and use the metal ruler to weight it down while it dries.

5. Mix some terracotta shades from watercolour paints and use the sponge to paint the white card off-cut for the terracotta pots. Leave to dry.

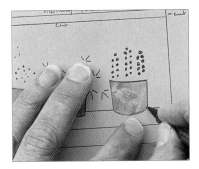

6. Cut the pot shapes from the template and use the cutouts to draw the pots on to the painted card.

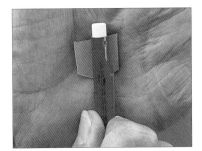

7. Cut out each pot, then use the rounded shape of a pen or pencil to create a slight curve in the card on the wrong side.

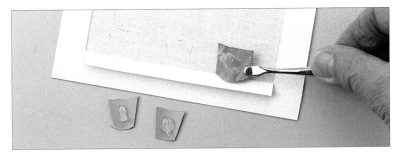

8. Glue the fabric on the back of the card, then, bearing in mind that curving the pots makes them slightly narrower, use the cutouts on the template to mark the position of the pots. Place a blob of silicone sealant in the hollow of each pot and position them on the fabric with tweezers. Leave to dry.

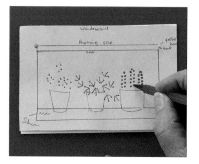
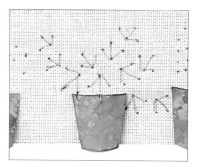
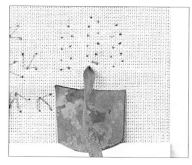

9. Pin the template through the fabric, prick the holes with a needle, then use a pencil point to mark the fabric through the holes.

10. Remove the template, then use the pencil to draw in the lines which denote the ivy leaves on the middle pot plant.

11. Anchor delph blue 4mm (¹⁄₈in) ribbon at the lowest hole of the centre flower in the right-hand pot, then give the ribbon a single right-hand twist.

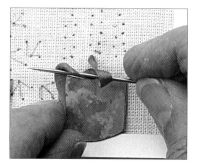
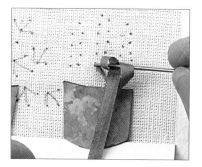
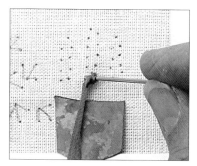

12. Place the needle over the ribbon and wind two loops round the needle.

13. Keeping the loops loose, put the needle very close to the original hole.

14. Pull the ribbon to form the right size of knot round the needle. Hold the ribbon close to the knot to keep the shape.

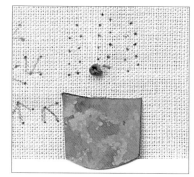
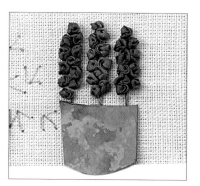
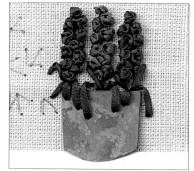

15. Still holding the ribbon on the front, pull it through to the back to complete the first French knot. Continue up the stem, finishing with a one-loop French knot at the top.

16. Work the other two flowers as before but with the deep blue 4mm (¹⁄₈in) ribbon. Use green coton à broder to work the stems.

17. Using 2mm (¹⁄₁₆in) green ribbon, refer to the bluebells on page 34 to work offset lazy daisy stitch leaves to complete this pot plant.

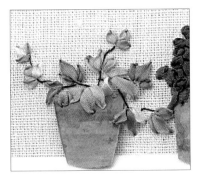

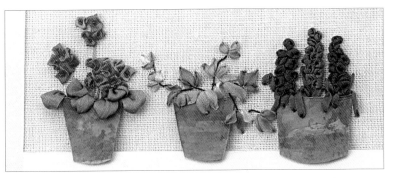

18. Mix blue and yellow silk paint on a tile to make two shades of green, drop in the cream ribbon and dye it very patchily. Dry and press. Each ivy leaf is a fan shape of three small ribbon stitches with smaller leaves at the end of each stem. Work two strands of brown thread along and under a run of leaves for a stem and use a single thread to couch and curve it in position at the base of each leaf.

19. Finally use the 4mm (1/8in) salmon and apricot ribbon to work the geraniums. Referring to the delphiniums on page 22, work the loops 4mm (1/8in) high and use two strands of deeper toned thread to work a one-loop French knot to pull each loop down. Work the stems in green coton à broder and the straight stitch leaves with 7mm (1/4in) moss green ribbon, taking some through the pot and silicone.

The finished card. The completed window panel was attached to the folded card blank with silicone to leave it slightly raised from the surface. So much can be done with this project – change the colours or type of flower, cut pots a different shape or use a mixture of textures. A single larger pot would look good – perhaps the recipient of the card has a favourite pot plant.

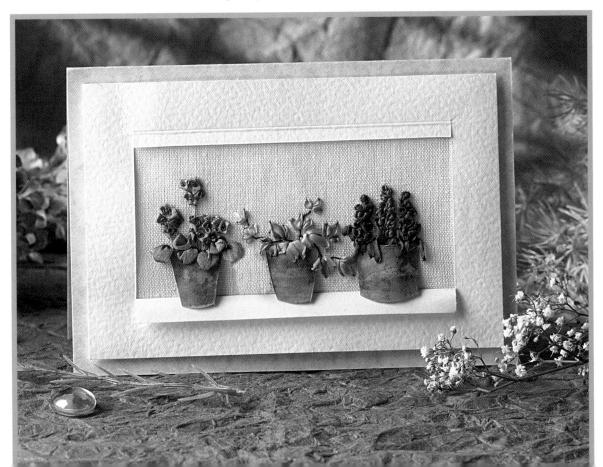

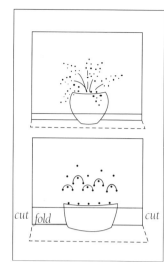

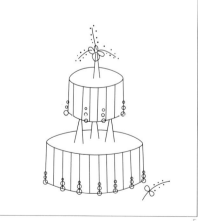

These templates for the cards shown opposite are all printed half size, so you will need to enlarge them 100% on a photocopier.

Clockwise from top left:

Lattice Cushion

Use a pretty fabric; silk dupion is used here. Place the 4mm ($\frac{1}{8}$in) apricot ribbon lattice, glue the ends in position, then glue the fabric into the card panel. Use a deeper shade of ribbon to work one-loop French knots (see page 38), then work the bow as in the finished card on page 27, using thread to scallop and position the edge. Place a piece of wadding slightly smaller than the aperture behind the fabric.

Lilac and Iris Window

Using all 2mm ($\frac{1}{16}$in) ribbon, work one-loop French knots for the pink and mauve lilac and refer to the Three Irises project (page 30) to work the iris in two shades of blue. Use a green thread for stems and add green leaves.

Cherry Blossom

Create the branch as in the Apple Blossom card on page 34 and see page 38 to work one- and two-loop French knot flowers with 4mm ($\frac{1}{8}$in) pink dyed ribbon. Add straight stitch leaves.

Celebration Cake

Cut out the shapes, glue them in place and work the straight stitch lines with an apricot thread. Anchor 4mm ($\frac{1}{8}$in) deep apricot ribbon at one side of the base and scallop the edge with a thread stitch. Now work the top edge and small cake. Use cream perle thread for the straight stitch pillars, then work rows of three-, two- and one-loop French knots with a paler ribbon and the heather with 2mm ($\frac{1}{16}$in) ribbon. Add green thread loops.

Modern Roses

Glue the black card triangle in position on the card, and fabric behind the hole. Work 4mm ($\frac{1}{8}$in) moss green ribbon straight stitch leaves, then use 2mm ($\frac{1}{16}$in) deep green and a toning thread to anchor the corners of the triangles (see the daffodils on page 34). Using 7mm ($\frac{1}{4}$in) cream ribbon, work two three-loop, two two-loop and a one-loop French knot. Now twist a length of 4mm ($\frac{1}{8}$in) copper ribbon into a tube, shape loops and secure with a thread.

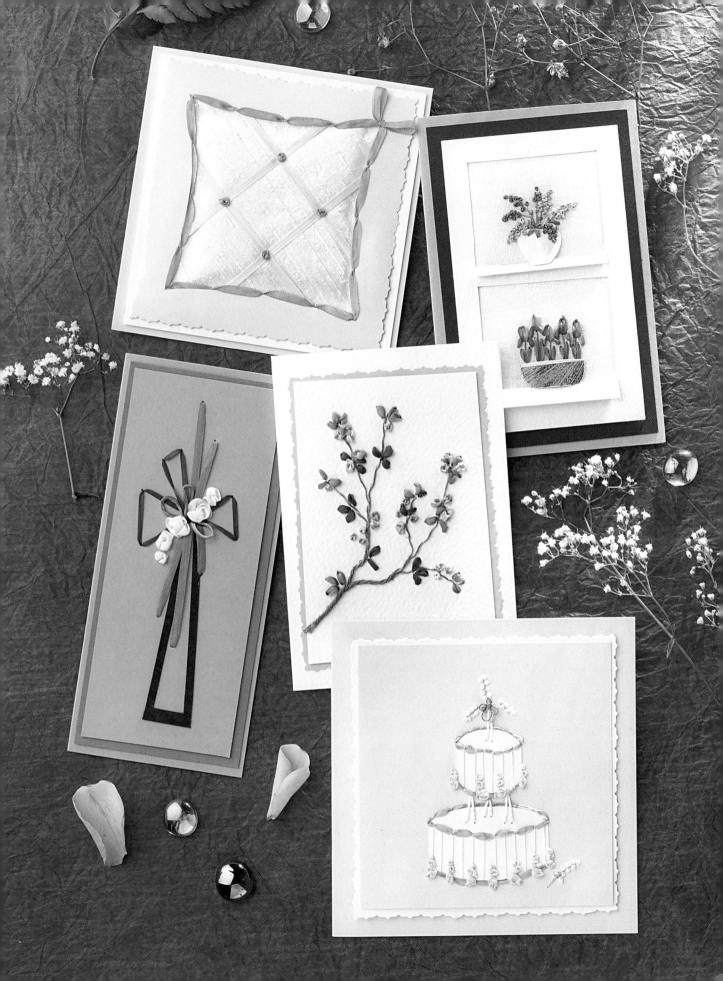

Choir Boy

This is a fun card with a seasonal theme, and it shows how versatile silk ribbon embroidery can be – you don't always have to make flowers! All the techniques have been worked on previous pages and I have simply adapted them here. You could change the colours or the background and with a little planning, the character of the choir boy.

You will need

Cream single-fold hammered card blank, 10.5 x 15.6cm (4¹⁄₈ x 6¹⁄₈in)

Cream hammered card, 9 x 14cm (3½ x 5½in)

Dark blue card, 10 x 14.8cm (4 x 5⁷⁄₈in)

Scrap card, 5 x 7.5cm (2 x 3in)

Watercolour paints, tile and paintbrush

Craft knife and cutting mat

Glue stick

Needles: two size 18 (medium) and one size 24 (small) chenille; one crewel size 8

Mapping pin

7mm (¼in) silk ribbon: 66cm (26in) of red (02) 10cm (4in) of white (03)

4mm (¹⁄₈in) silk ribbon: 50cm (20in) of purple (85) 25cm (10in) of pink (03) 13cm (5in) of moss green (20)

2mm (¹⁄₁₆in) silk ribbon: 25cm (10in) of cream (156)

15mm (½in) pith ball and coloured pencils

Clear silicone sealant

White and green embroidery thread

PVA glue, small brush and silver glitter

The pattern for the Choir Boy card. Photocopy it to make a template.

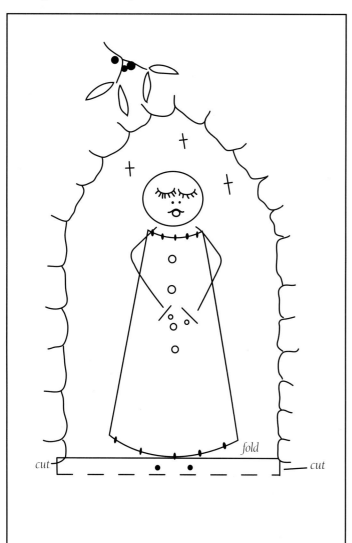

1. Cut out the arch shape from the piece of cream card, then fold down and secure the step as shown in step 4, page 37. Apply colour to the edge of the arch, then, using clean water, pull the colour out to indicate the stonework round the arch.

2. Cut the body shape from the scrap card and cut five lengths of red 7mm (¼in) ribbon, 2cm (¾in) longer than the body shape.

3. Apply glue stick to the top and bottom of the body, then attach one length of ribbon so that it just overlaps one of the sides.

5. Make four holes for buttons with a mapping pin and use 4mm (⅛in) purple ribbon to work a one-loop French knot into each one.

4. Repeat with another length on the other side. Now attach two strips slightly overlapping the first two, then attach the last length down the middle.

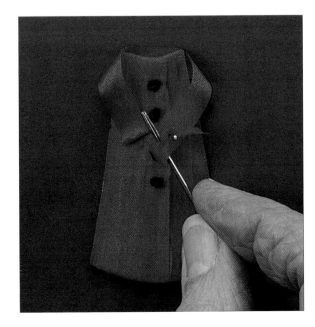

6. As in steps 7–8, page 37, slightly curve the body and place it on the blue card. Place a 20cm (7⅞in) length of red ribbon behind the top of the body and glue both to the blue card. Leave to dry. Work a centre ribbon stitch with the second needle at the cuff edge. Repeat for the other sleeve. Anchor all ends at the back.

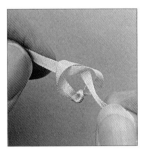

7. Tie a double knot in a length of 4mm (⅛in) pink ribbon.

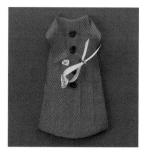

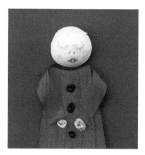

8. Pull the knot tight, then take both ends down under the end of a sleeve to form a hand. Repeat for the other hand. Anchor the ends on the back of the card.

9. Cut the 15mm (½in) pith ball in half, then use coloured pencils to add facial features. Position the head with silicone and leave to dry.

10. Make a running stitch through the middle of the length of white ribbon. For clarity, I used red thread, but I suggest you use white.

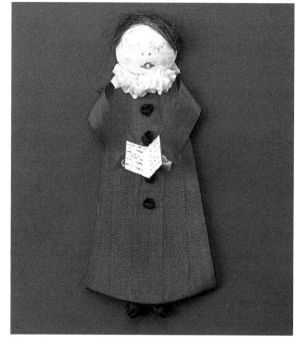

11. Take the ends of the thread down through the card on either side of the choir boy's head.

12. Pull both threads to gather the ribbon and form a ruff. Neaten the ends by tucking them under the ruff. On the back of the card, tie the threads together and trim off the excess.

13. Use 4mm (⅛in) purple ribbon to make the shoes in a similar manner to the hands. Add some hair (I trimmed some of my own), then fold a small piece of card in half and draw a few lines for the hymn book. Glue it in position to complete the choirboy.

14. Work the mistletoe on the arch. Use two strands of green thread for the stems and 4mm (⅛in) moss green ribbon for the straight stitches leaves. Use 2mm (1/16in) cream ribbon to work two-loop French knots for the berries.

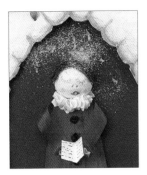

15. Place but do not yet glue the arch card over the blue card, then use PVA glue and a brush to define some star shapes behind the choir boy. Sprinkle glitter on the glue.

16. Remove the excess by holding the card at an angle and tapping it gently. Stick the blue card to the card blank, then use silicone to attach the arch, slightly raised, on top.

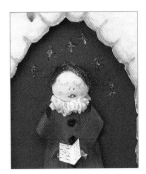

The finished card. This is an unusual Christmas card, and the mistletoe adds a bit of fun

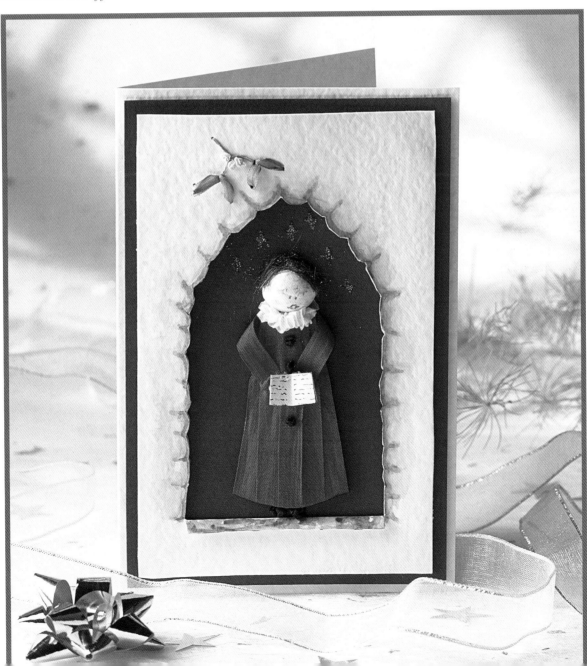

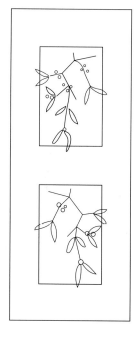

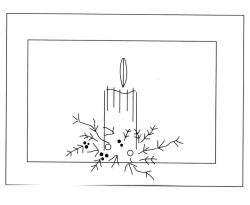

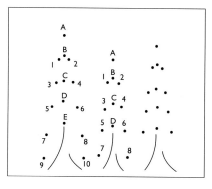

These templates for the cards shown opposite are all printed half size, so you will need to enlarge them 100% on a photocopier.

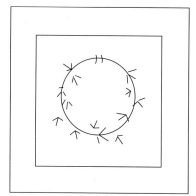

The template for the Poinsettia card shown on page 1. The template is half size so you will need to enlarge it 100% on a photocopier. Using 7mm (¼in) red (02) ribbon, work the longest petals round first, then work the shorter petals round. Work French knot centres with orange and yellow threads and stem and ribbon stitch leaves to complete.

Clockwise from top left:

Mistletoe

Referring to page 44 step 14, work the stems, leaves and then the berries.

Christmas Candle

See page 37 steps 7 and 8 to place the candle. See page 39 step 18 to dye a 4mm (¹/₁₆in) white ribbon and work the ivy. Using 7mm (¼in) white ribbon, work the straight stitch rose petals and stamens with yellow thread. The conifer is small fly stitches worked in a green thread and the berries are two-loop French knots with 2mm (¹/₁₆in) red (02) ribbon. Using 4mm (¹/₈in) candle-coloured ribbon, work the straight stitch drips. Use 7mm (¼in) yellow ribbon for the ribbon stitch flame.

Christmas Trees

Anchor the ribbon at A and work a left ribbon stitch at 1 (see page 12 step 11). Keep this needle in place as you bring the needle up through A again. Now work a right ribbon stitch at 2 but bring the needle up at B this time. Continue on down to work the remaining branches. Work a straight stitch trunk, curved to shape with a brown thread.

Ivy Garland

Draw a circle on to the card. Cut a 20cm (7⁷/₈in) length of garden string, untwist it to make four to five strands, then wrap the ends round, forming a circle to fit the card. Secure it using silicone. Using 4mm (¹/₈in) green (21) ribbon, work the ivy (see page 39 step 18), then make a bow with 7mm (¼in) red ribbon and secure it with silicone.

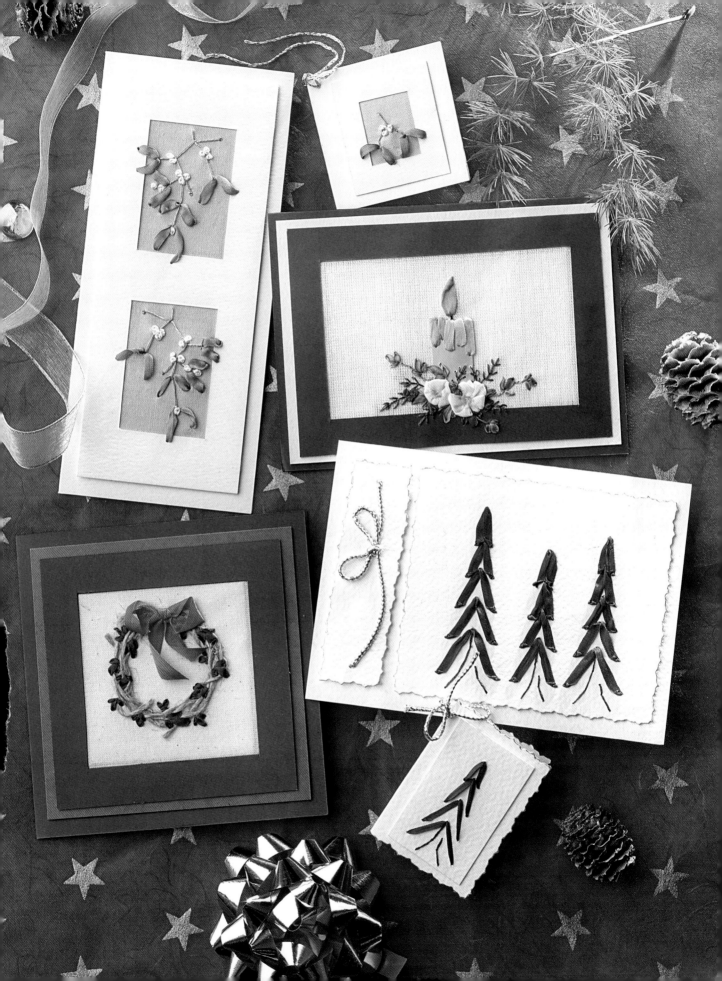

Index

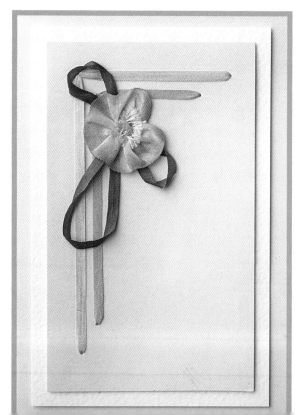

Apricot Blossom

A 10cm (4in) – plus tails – length of 13mm (½in) pale pink (05) ribbon is painted then gathered. Work as for the poppies on page 28 but cut a round hole and use a size 24 chenille needle to take the ribbon through the fabric. Work yellow stamens, then the two design lines (see page 28) with 4mm (⅛in) apricot (167) and pale apricot (166) ribbon, then add three loops of deep moss green (21) ribbon to complete.